I LONG FOR A
LOVE
THAT CAN
DROWN
OCEANS

I LONG FOR A LOVE THAT CAN DROWN OCEANS

Poems

Written and Illustrated by Brooke Riley

To me
goddam, you actually did it.

Contents

FLOAT
1

ABSORPTION
13

BUBBLES
33

FREEZE
51

FLOOD
61

BREATH
79

"I'm a writer; anything you say or do may be used in a story."

I LONG FOR A
LOVE
THAT CAN
DROWN
OCEANS

float

Floating

I'm floating around aimlessly in the feeling of content.
The water is calm and silent.
I'm floating around in thoughts of you.
Everything is sparkling
A storm is on the horizon, and we don't have much time
But right now, I'm lying in crystal clear water
I'm soaking up the peace and joy of the world
It's mine now
The storm will be here soon,
And the flood will follow
But not yet
For now
I will keep floating.

KINDA, SORTA, MAYBE

I've never felt this way before,
I don't know if I want it to end or if I want it to last forever
I try not to stare
I try not to show that I lied
I want to tell you how I feel
But the voices in my head tell me to hush
I keep words deep inside me
Never uttering a sound
Let me tell you a secret
I kinda, sorta, maybe, possibly, might like you.

We clung to each other like we were each other's lifelines in a vast ocean, desperate for security and comfort.

If only you knew the effect you have on me

I DIDN'T PLAN TO LIKE
YOU THIS MUCH AND I
NEVER INTENDED TO
HAVE YOU ON MY MIND
THIS OFTEN

I'M SORRY IF I AM BEING CONFUSING, I CONFUSE MYSELF ALL THE TIME

GLASS HEART

You inspire me to write.
The way you soar, swim, and hunt,
Invading my mind all day and through the night.
I'm always dreaming about the times to come.

Let me count the ways
That your soul affects mine:
You're terrific blissful and light
Wanting your nonsense fills my days.
Now I must hide away with my glass heart Just in case you tear me apart.

Meeting you was like opening a brand new book for the first time, and upon reading the very first sentence, you know it will be your favorite book, but you also know that it will completely destroy you by the end.

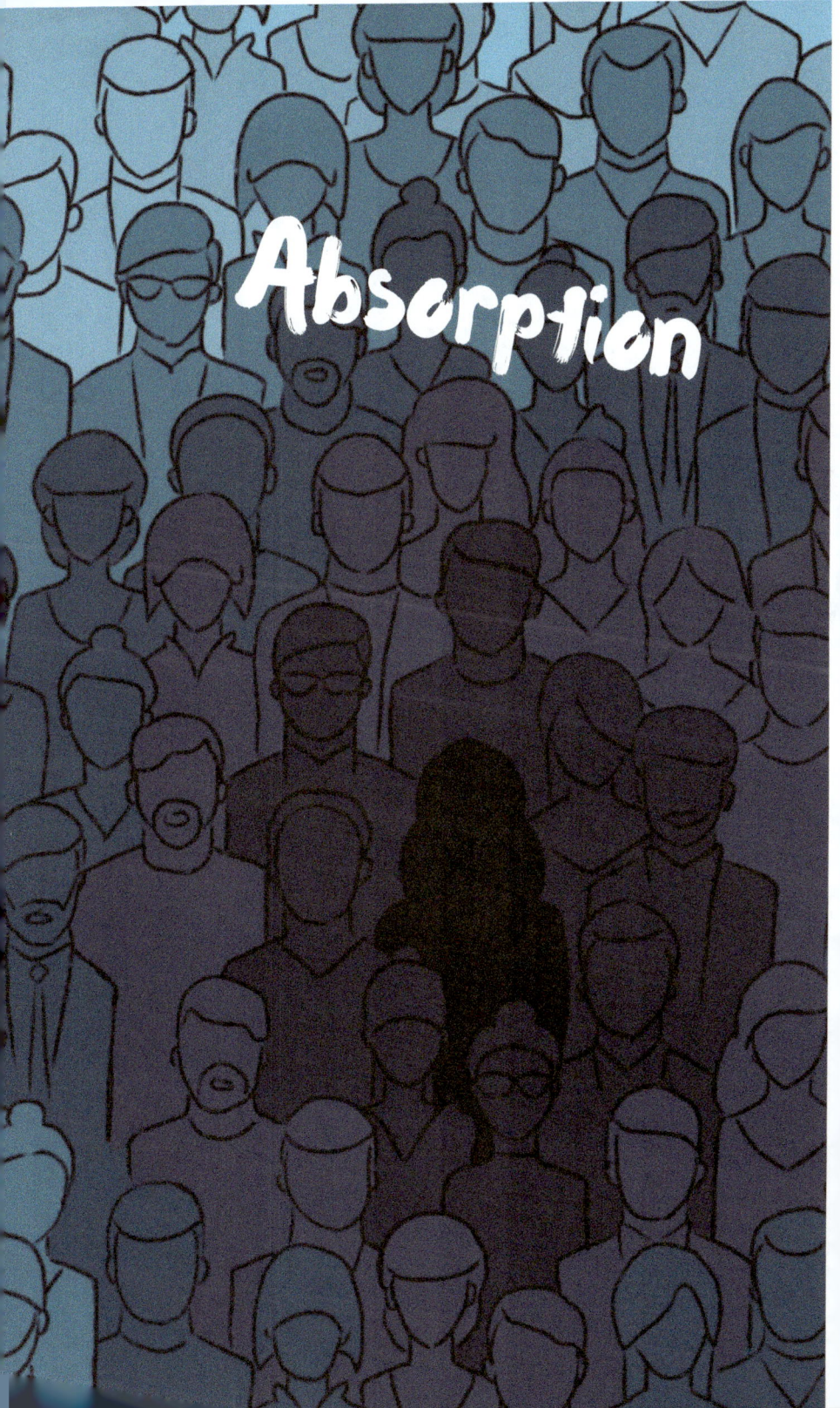

THE NUMBNESS DOESN'T GO AWAY WITH TIME, IT SUBSIDES A LITTLE BIT BUT NOT THAT MUCH AND NEVER FOR A LONG TIME.

Scheduled

I was scheduled to come into the world

My mother told me so
An appointment was made
And I was born
Ever since then, I've been planning

Planning
I plan everything
From my clothes for the week to the things that I eat
Creating alarms to go off throughout the day
Telling me what to do and when to do it.
I plan.

Rehearsal
I rehearse everything
From the scripts written and memorized before conversations
To the laughs in the mirror.
I polish my every move to perfection
Leaving no room for error.
I rehearse.

I'm scared.

From the precarious planning masked as teenage defiance
To the months of research disguised as impulse.
My lack of spontaneity scares me sometimes
I have a very strict Schedule that is completely unnecessary.

I was scheduled to come into the world.

I'm way too young to feel this old

I tend to abuse sleep

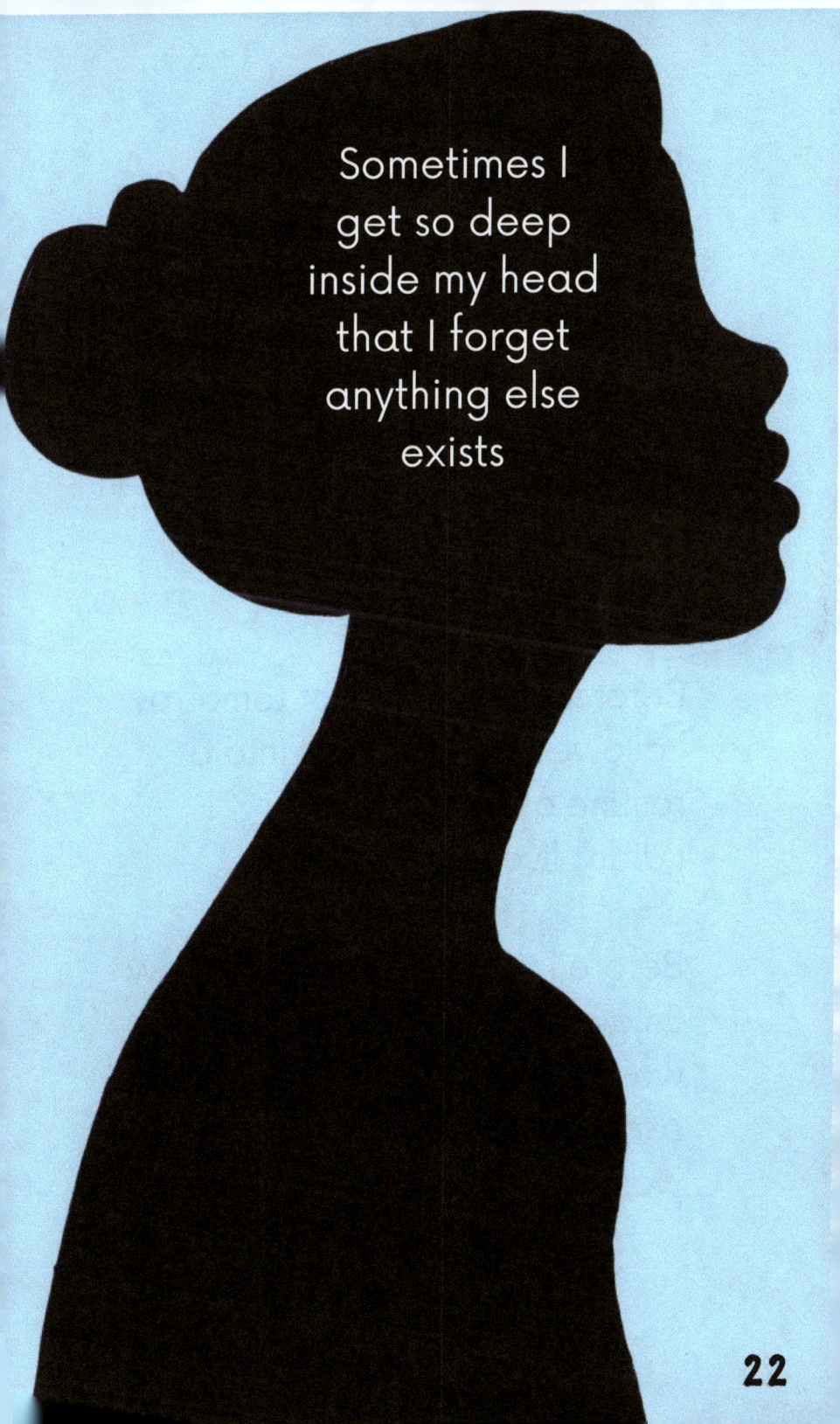

Before I was afraid of tomorrow

Before I was afraid of tomorrow
I wasted my days,
Doing nothing, passing the burden onto the tomorrow version of myself

Before I was afraid of tomorrow
I allowed myself to fall into a routine of tranquility.
I didn't live in fear.

Before I was afraid of tomorrow
Enjoyment was easy and stress was scarce
Leisure was the norm and dread was rare.

Before I was afraid of tomorrow
I did what I wanted
I ate what I wanted
I said what I wanted
And I wasn't afraid to do nothing.

Before I lived in fear, I lived in peace
Before the consuming dread, I didn't care
I didn't care about tomorrow
It was just a day.

The days before
 I was afraid of tomorrow
 were a long time ago

WASHED AWAY

We will all be washed away someday
Our words will be erased.
Footprints in the sand will fade.
Notebooks filled with thoughts will be burned.
Our childhoods will be covered up.
Everything we have done will not matter.
The trees we carved our names in will be cut down.
Pictures will be lost.

A century from now, we will be forgotten.
But they will see the same stars as we did.
They will see the same mountains as we did.
They will talk to the moon like we did.
They will tell stories around campfires like we did.
They will make art like we did.

And maybe, just maybe
Someday, someone will
come across an old
photo or notebook.
Maybe they will wonder
about us;
The things we said, the
things we did.
Maybe we won't be
forgotten.
We won't be washed
away.

Rewritten

~~It's not okay~~ Maybe ~~I am completely
broken. And everything is
falling apart,~~ it is ~~crumbling
Down around me, help.
Nothing is~~ okay, ~~I need help.~~
Maybe ~~I am dying~~,
~~I am not okay~~
I am ~~not~~ fine, ~~please help
someone?
Anyone?~~

Untitled

There's a pain worse than heartbreak. It's not something caused by other people, and it's not even your fault.

When something that you enjoyed, something you loved doing, becomes a chore, something that once brought you joy now brings you boredom and stress.

People will let you down; it's to be expected, but when your favorite hobby does, it's devastating.

I've always looked too deep into something or someone. That's because I realized from a young age that there is always more than what meets the
Eye

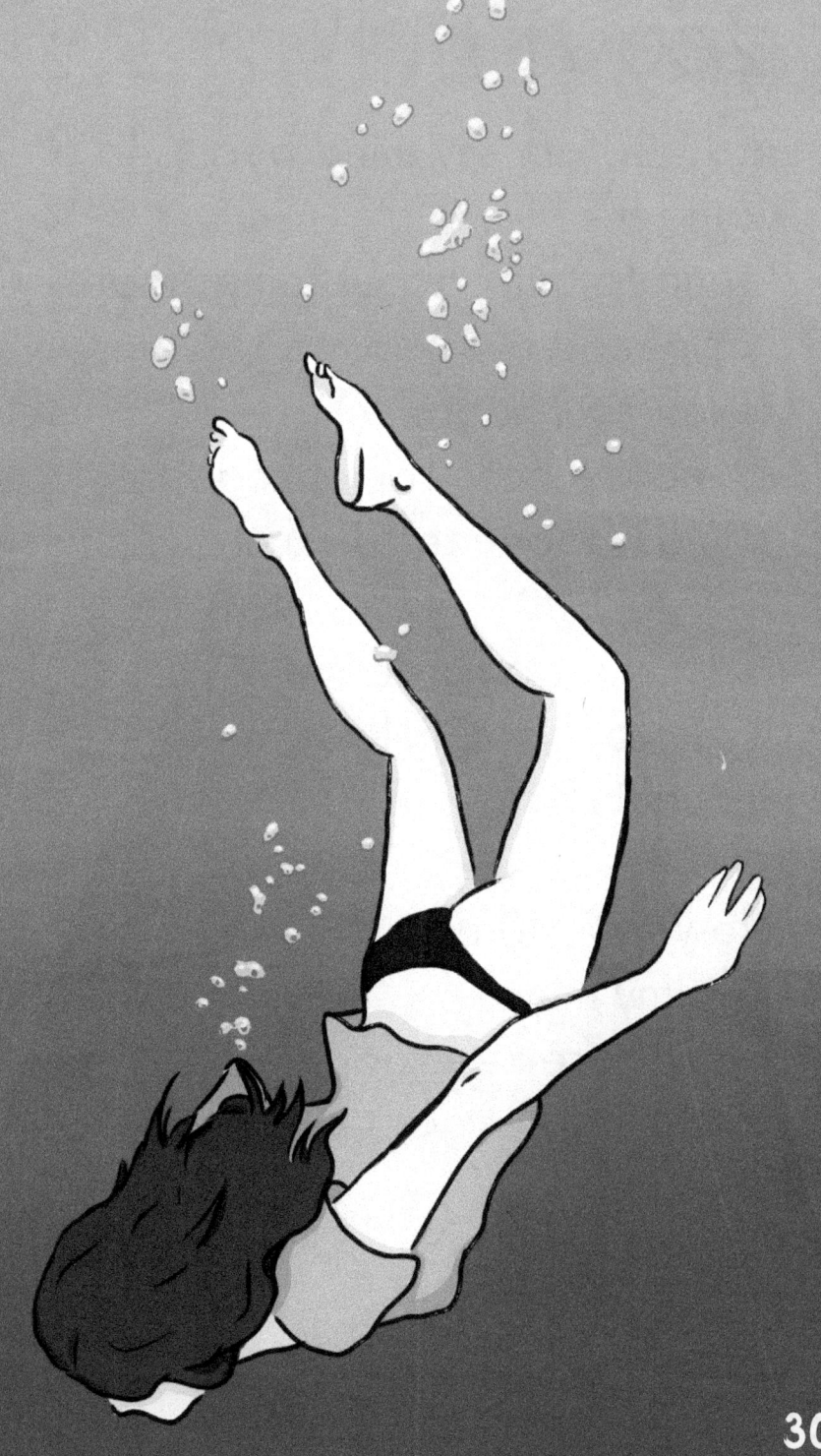

12:00 AM

At 12:00 am, my mind begins to wander.
I tend to think about things that happened five years ago,
seven hours ago,
or maybe even something that could happen ten years from now.

My mind is a hurricane, it's a wreck.
It's full of beautiful yet awful thoughts.

Now it's 1:00 am,
and my mind
is nowhere near done wandering.

Google

How to disappear completely and never be found again

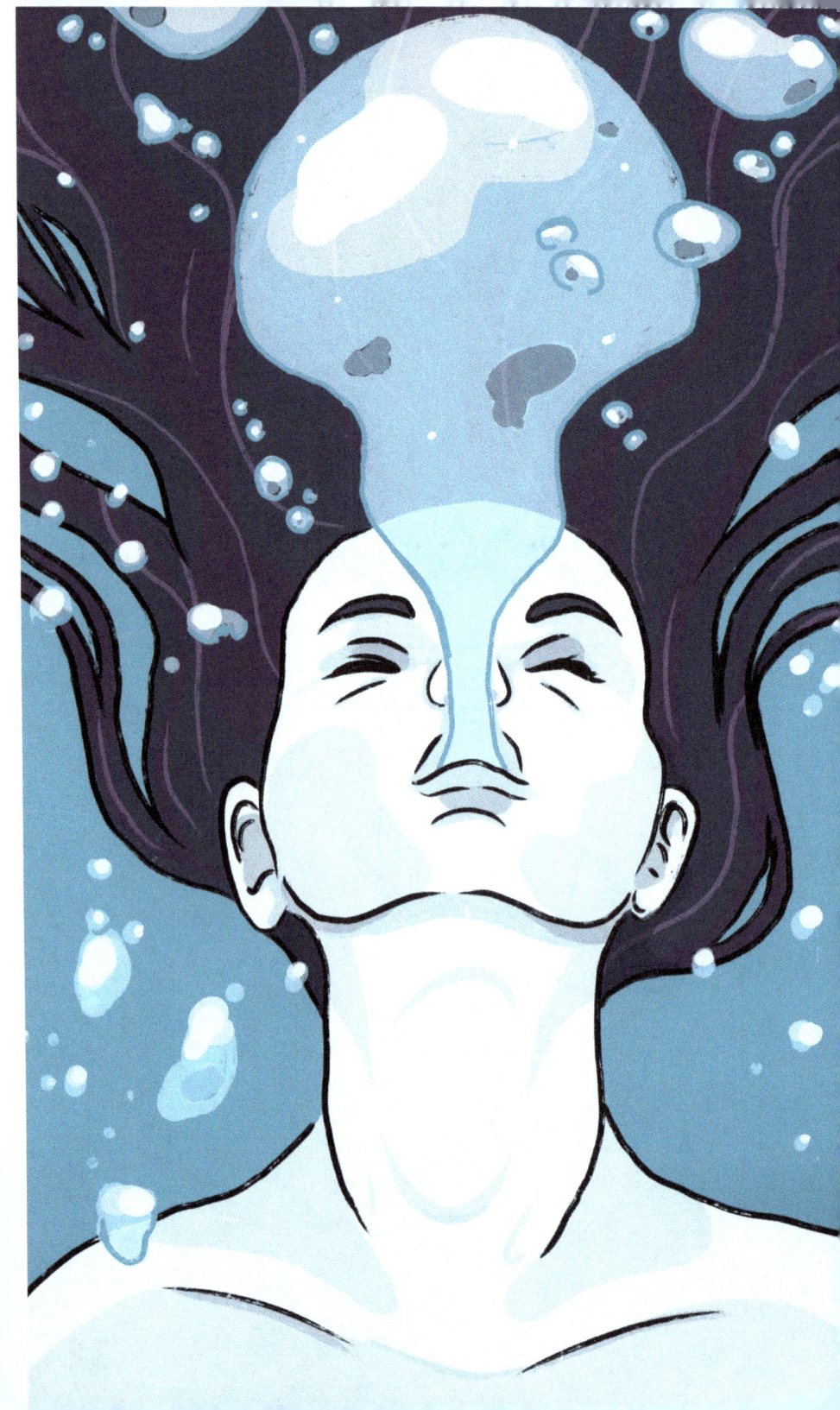

Bubbles

WONDERING

I wonder if things would have
turned out differently
If I had told you what I was
feeling

If things would be better now
If I had just said or done one
thing different.

I wonder if I would be happy
If I had just been a little braver
Or a little bit less like myself.

If I would be happy
If you were here.

I wonder.

DREAM

Last night I had a dream that you texted me.

I was on the edge of sleep when my phone lit up with your name,
you said something like "hello there" or "hey, how's it going?"

And I laughed at how stupid it was.

I thought about how much of an asshole you are, saying something like that after months of no contact.

But a smile still split open my face even though I knew that I should hate you.

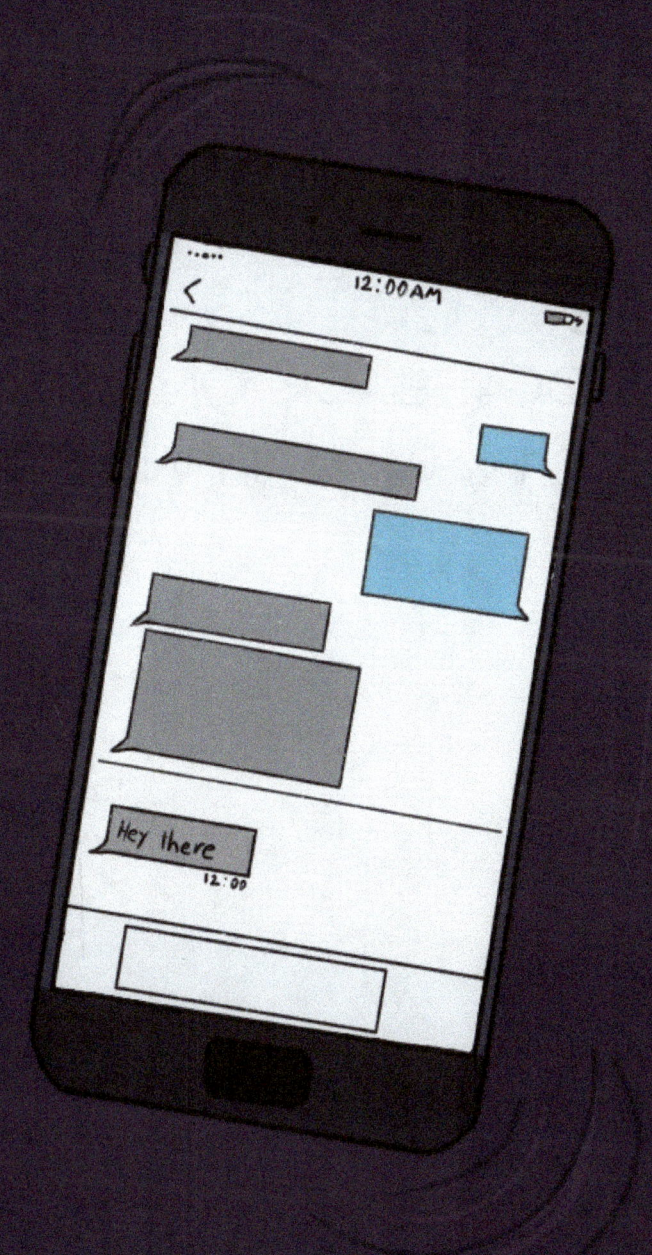

IT'S EMBARRASSING TO LOOK BACK ON BUT DAMN, WAS I HAPPIER

I have a habit of expecting to much of people.

I'M NOT GOING TO ASK YOU TO STAY BUT I WANT TO.

It's astounding how two people can talk for hours and never learn a thing about each other.

SOMETIMES I WISH I
NEVER MET YOU

Moment

Walking home, my mind got stuck someplace else. There was nothing wrong with the moment, in fact it was perfect. The air was freezing against my face, but his hand was warm, he was humming quietly, a song that I didn't recognize. I wanted to be there in that simple yet wonderful moment, but I wasn't and now it's gone.

That night broke me,
but the remembering
and vivid reliving might
just
kill me

Sometimes silence isn't comfortable, it's vacant

I'm drowning; I know an overused, overdramatic metaphor, but it really does feel that way; it's like every day without you may as well have been spent at the bottom of the ocean. I can't hear anything. I can't breathe.

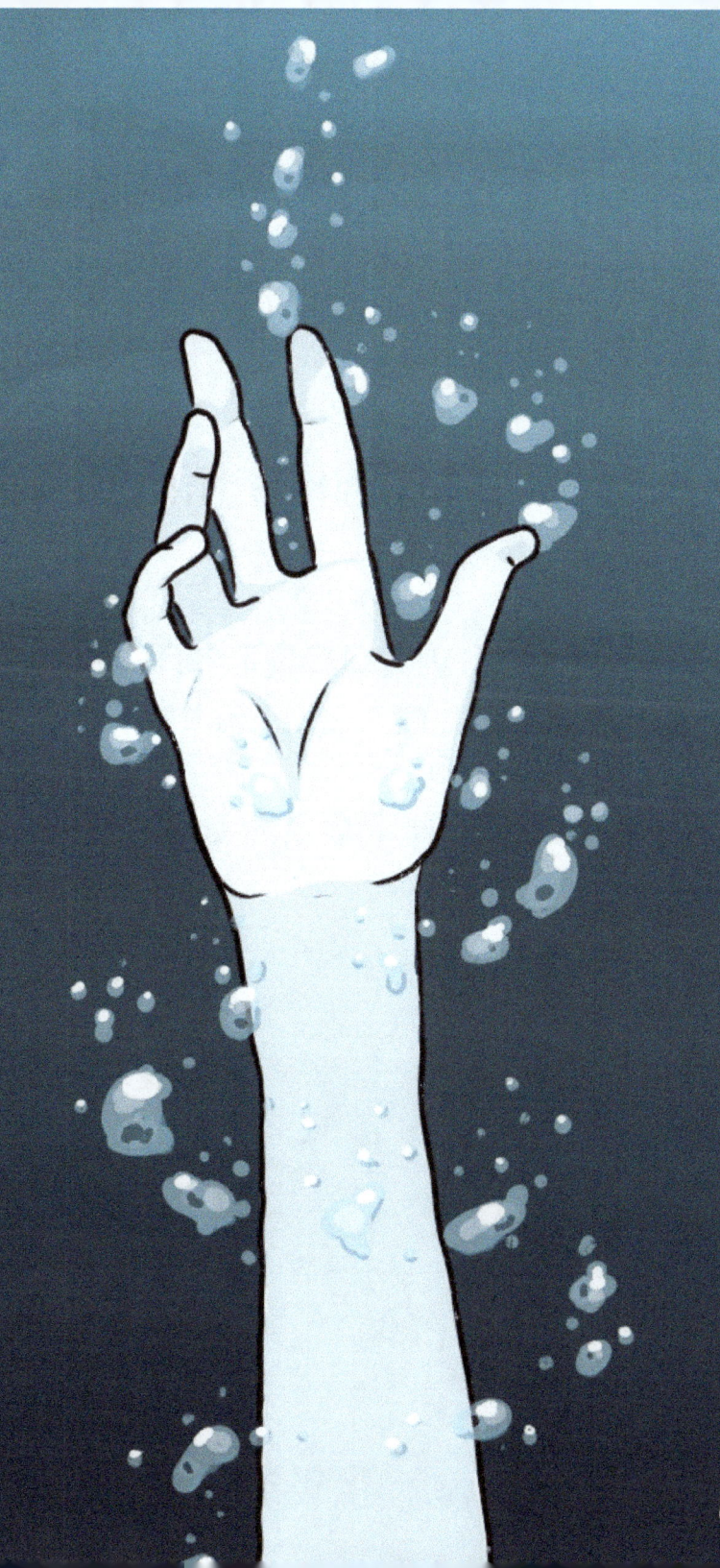

"Do you still like him?"

"Honestly I don't know, but there's something about him I can't let go of"

I WANT TO WRITE ABOUT SOMETHING ELSE OTHER THEN YOU BUT MY

PEN

WILL BE LOYAL TO YOU FOREVER

Frozen

I was frozen,
 his gaze turned my insides to ice
 and I was stuck
 to the pavement like the snow.

I was frozen in that eternal second,
 time slowed
 and I was frozen.

Some moments just don't end,
 that's your fault,
 you did that to me.

Quiet

The darkness calls me to the wintery woods
to rest in the silence
I wander through the trees
Snow whirls down around me
my feet sinking deep
Fluffy flakes dissolve once they touch my face
It lays its blanket on every tree
I sit on the cold white forest floor and listen:
Nothing

It's a sound that's not a sound at all
It's a quiet dream
I sit and watch the flakes
As they work together to build walls higher and higher
I watch the still, white darkness
It wraps around me in a soft embrace
It comforts my tired soul as I sit
and watch
and listen.

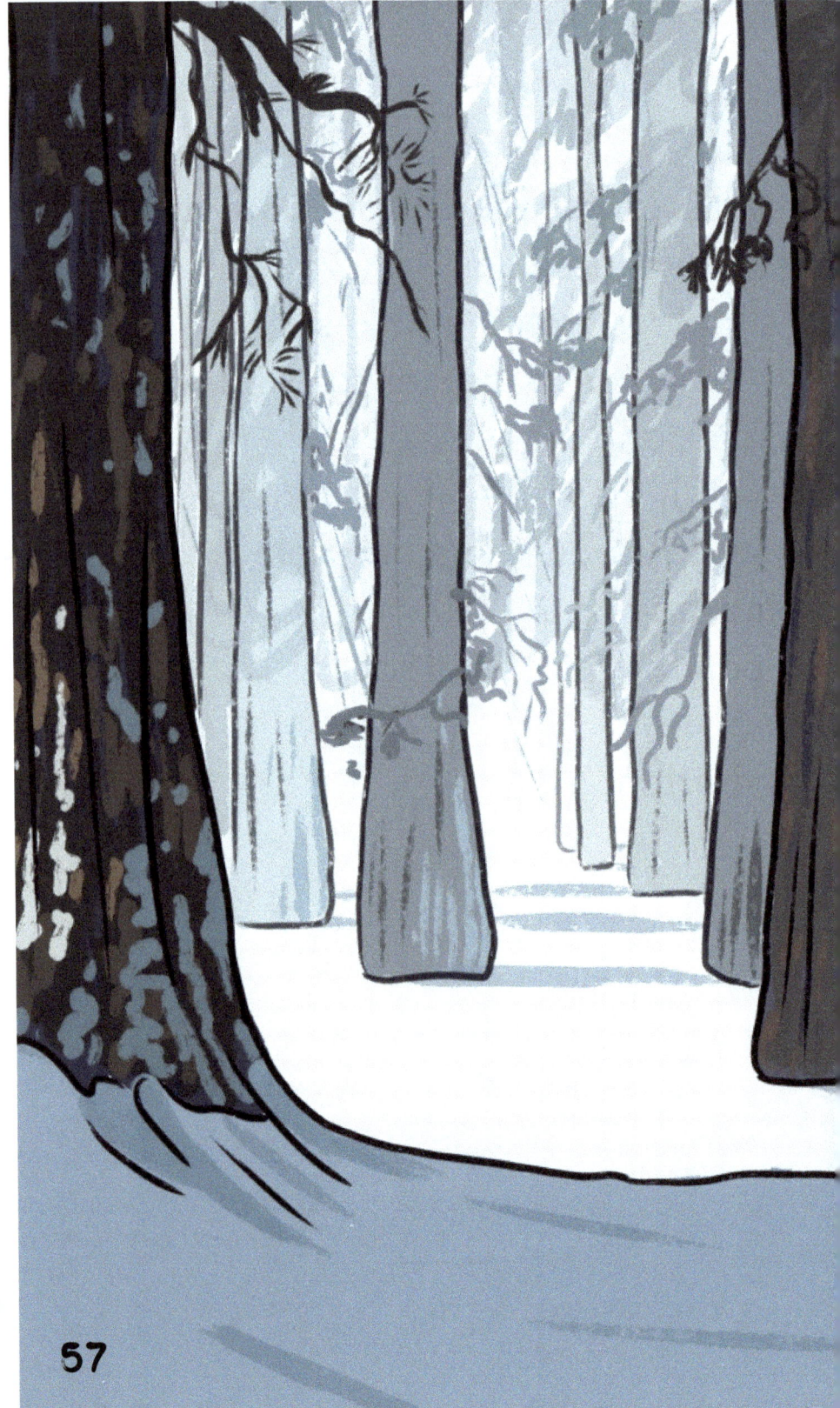

If you listen closely,
you will find that the
silence is

Beautiful

winter

Today was the first snow of the winter.
It made me think of you.
Walking late at night,
the wind sending white flakes
spiralling around us.
One hand
holding a warm tea,
the other in yours.
Wet socks and rosy cheeks.

The sound of my laughter as you
fall through the ice i told you not
to stand on.
I fell in the snow,
you pulled me up
he calm quiet of
snow will always
remind me of you.
But this snow isn't calm or
peaceful. It's aggressive and
untrustworthy.
It tells me that it's been a year
since everything felt simple,
perfect.
Crazy right?
 It feels like I've lived
 centuries with this pain.

flood

I WAS RIGHT ABOUT
YOU,
DAMMIT,
WHY DID I HAVE TO
BE RIGHT

OF COURSE I'M ANGRY,
I'M ANGRY ALL THE
TIME.
MY ENTIRE LIFE I'VE
BEEN FIGHTING A WAR.
I AM SOAKED IN PAIN
AND SADNESS.

Some people are born with pain built in,
==it's inevitable.==

I JUST WANT SOMEONE TO TELL ME HOW TO LIVE MY LIFE BECAUSE I FEEL LIKE I'M DOING EVERYTHING WRONG.

I think that all my butterflies died

I want a lot of things:
 I want my mind to shut up
 I want my body to not reject itself
 I want the world to go away
 And I just want everything to stop
Everything needs to stop

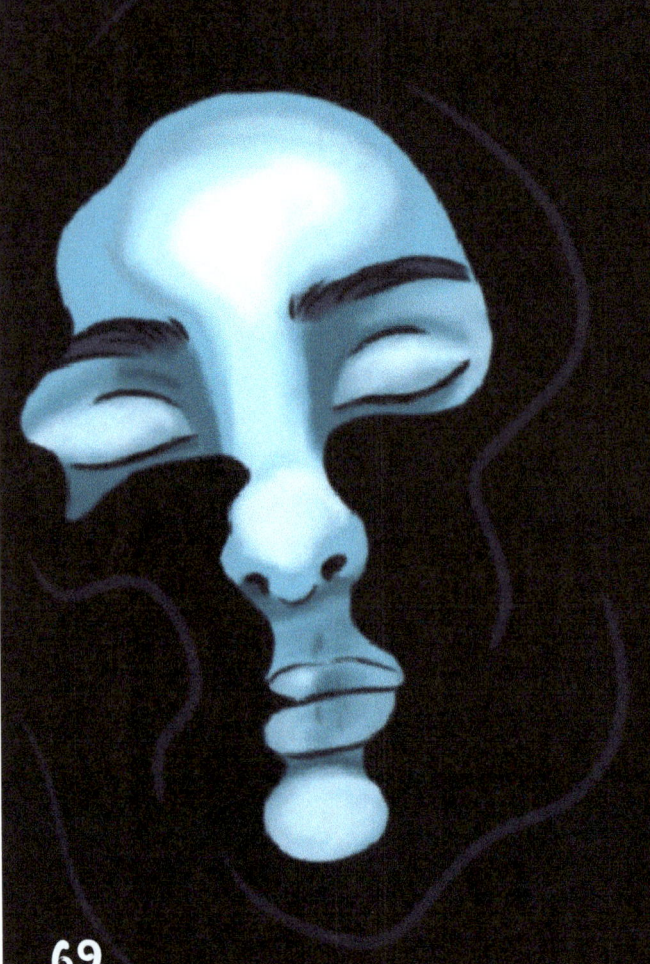

I hate how in a crowded room I will always look for

.y̲o̲u̲

STORM

Don't believe the storm is unexpected
The storm is expected beyond belief
A storm is forced, a storm is planned.

Don't believe that the tornado is kind
The tornado is violent.
Never forget the vehement tornado.

Don't think that floods are nice just because they're wet
Flood waters are angry tears that can tear the world down.

I witnessed the chaotic windstorm
of my generation destroyed
I mourned the wild and disorderly whirlwinds
Don't believe you're safe from the storm
just because it's inside you.

You can't control it
A storm, however hard it tries, will always be vicious
A storm is roughshod,
A storm is wicked,
cruel
and unforgiving.

The art of hating someone you love

You wait until the last minute to close your eyes.
You only talk about it to the stars.
You only cry when you're alone.
You only pour your heart out to strangers on the bus.
You only scream inside your head.
You only allow yourself to think about them when the sun goes down.
"It's hatred" you say, contradicting what you've said before.

You look for them in a crowded room,
hoping to see them but dreading their presence.
You keep the photos but never look at them.
You block them but still wait for them to call.
You count the days since you last saw them
but can't remember the last thing you said to them.

You confuse desperation with hope.
You see the world differently than you did before.
You feel older.
You find it unsettling how hatred can feel a lot like love
And you still cry about it long after you say you've moved on.

HOW COULD I TRUST
YOU WHEN I'M STILL
COUGHING UP WATER
FROM THE LAST TIME
YOU LET ME DROWN

I have this irrational fear that

I'm

Running
out
of
time

To find myself

*I know nothing,
I don't understand anything*

Maybe one day I can learn how to be angry

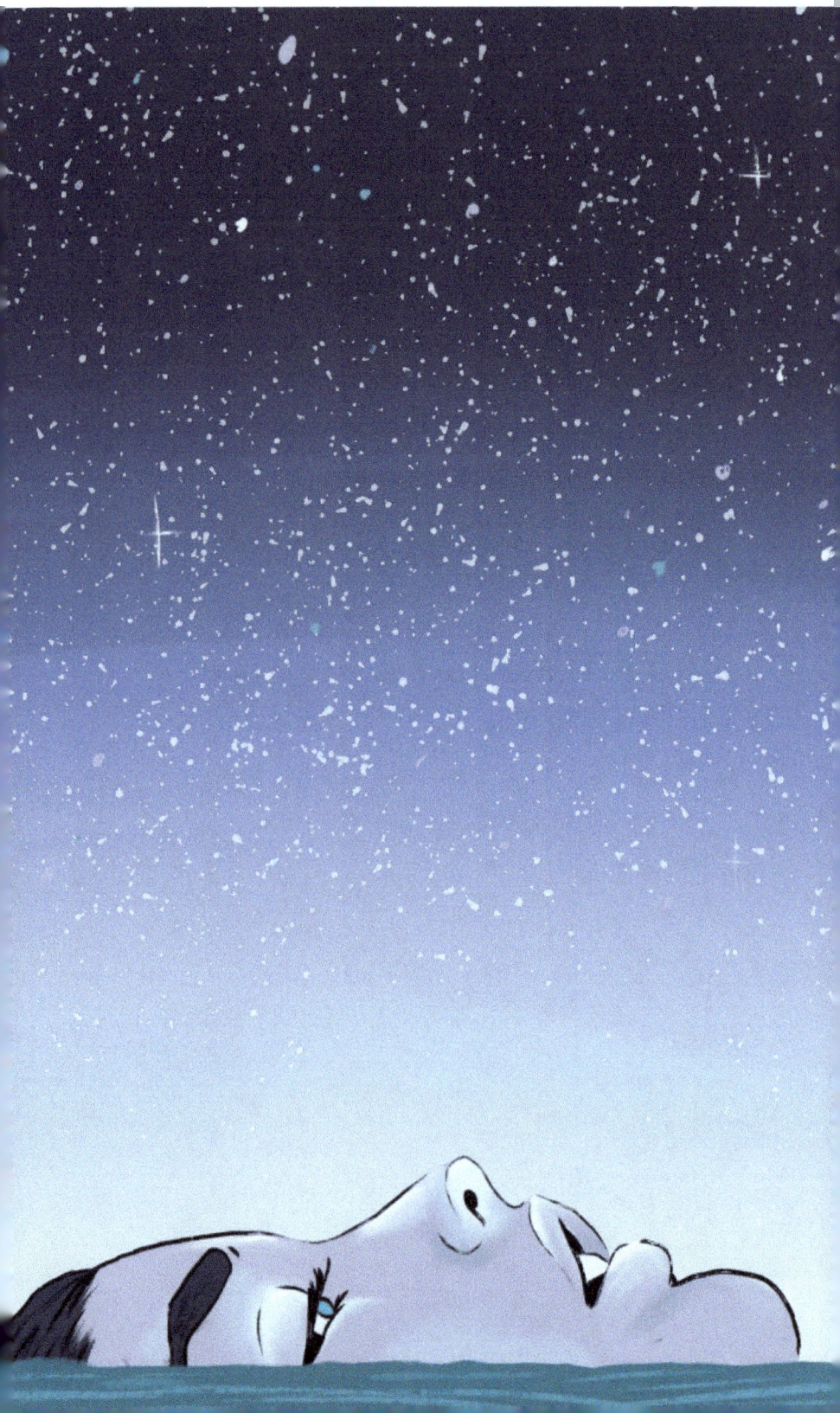

breath

YOU WALKED AWAY
AND ALL THE
FEELINGS I NEVER
TOLD YOU JUST
BECAME

POEMS

Thirteen

I'm not thirteen anymore
Thirteen brought sadness,
loneliness, and pain.
Thirteen was a different country
Thirteen was a rollercoaster

I'm not thirteen anymore
Thirteen wasn't me
I didn't look like me
I didn't act like me
I didn't feel like me

I'm more me now than I ever was at thirteen
Thirteen was a long time ago
But it was also yesterday
And the day before.

Thirteen murdered familiarity
I am not thirteen anymore,
And I never will be again.

I hate falling asleep
because I know that you'll
be waiting for me in my
dreams,
with all the words you never
said
and the perfect moments
that never happened.
I hate falling asleep,
it just shows me all the things
I could have had.

I'm nothing special really, I'm just a girl who tried to hard and got accused of not trying enough

I LAY AWAKE AT NIGHT, UNABLE TO SLEEP BECAUSE MY MIND IS ALIVE WITH WORDS FOR SOMEONE WHO WON'T EVER HEAR THEM.

Love

The psychologists say that happiness shouldn't be difficult
They say that love should come easy
But that's not what the stories taught me
The poets say that love is a swordfight,
that love should be dangerous
If a love doesn't strike fear into you, it isn't real

But what do I know about love?

Nothing.

I just follow words already written
and declarations already spoken
But I'd rather listen
to the poets of the world than
the psychologists.

After all, nobody reads stories about the loves that come easy.

THE WORDS IN MY
HEAD OUTNUMBER THE
WORDS I'VE SPOKEN

WATERMARKS

I have never liked love stories. I always thought they were too sentimental and unrealistic until I started living in one. All the clichés I've mocked, all the tropes from the movies at which I've rolled my eyes, every single one became real. From the moment he first spoke to me, I knew my life would never be the same again.

People are like waves; they come and go, leaving small marks in the sand. Sometimes, a big wave comes in, its roar so loud it's almost deafening, and it leaves deep marks behind.

He was a big wave; he crashed into me with the strength and intensity of a freight train.

I've always prided myself on being logical, a realist, so I knew that it wouldn't work out in the long run, but I still whispered a shaky "okay" against his lips because despite my gut telling me that it would end horribly, I wanted to be someone I wasn't.

I wanted a picture-perfect love story like you to see in stories, so I ignored that feeling in my gut and allowed myself to become the girl in one of those clichés.

I experienced the late-night conversations when the rest of the world was asleep, the dates at restaurants, the cuddling, the kisses; I also experienced the silence that followed "I love you".
I lived through the heartbreak and lonely nights.
Now I understand break-up songs with full clarity, and I relate to the heroines in tragic romance books.

I feel like I aged ten years in that short time. I feel like I see things differently than I did before. I have watermarks on my skin that will never fade away.

Climbing the ladder just to go down the slide

Three more months until don the cap and gown
Five more months until I blow out the candles,
Singing the song of adulthood
And what happened,
Where did the time go?
Seven more months and I'll be starting again.
I've been climbing this ladder all my life,
And I've finally reached the top.
Now it's time to go down the slide.

~~Things that I have learned~~
Things that I have taught myself

1. Poetry doesn't have to be confusing
2. It's okay to still cry over things that you say you have moved past
3. You're allowed to mourn something you never truly had
4. You will eventually let go of the illusion that things could have been different

www.ingramcontent.com/pod-product-compliance
Lightning Source LLC
Chambersburg PA
CBHW072217170526
45158CB00002BA/635